How to Make a Comic Book

M. Usman

Entrepreneur Series

Mendon Cottage Books

JD-Biz Publishing

Download Free Books!
http://MendonCottageBooks.com

All Rights Reserved.

No part of this publication may be reproduced in any form or by any means, including scanning, photocopying, or otherwise without prior written permission from JD-Biz Corp Copyright © 2015

All Images Licensed by Fotolia and 123RF.

[Entrepreneur Book Series](#)

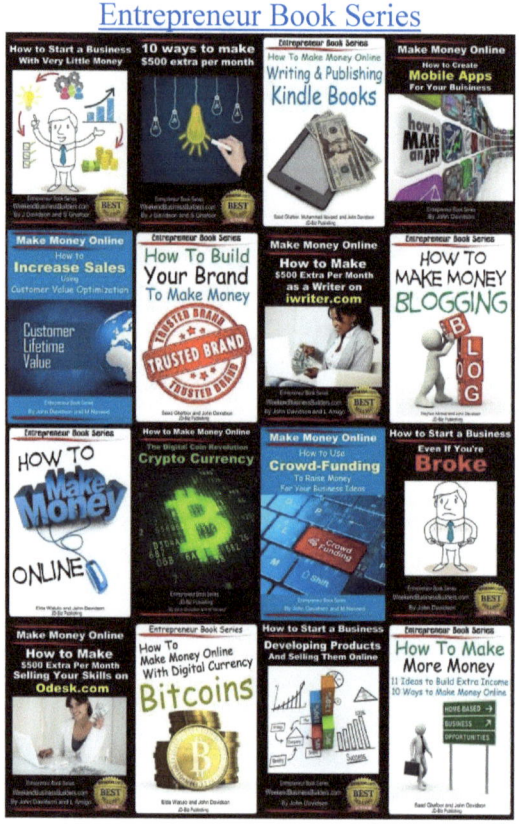

Our books are available at

1. [Amazon.com](#)
2. [Barnes and Noble](#)
3. [Itunes](#)
4. [Kobo](#)
5. [Smashwords](#)
6. [Google Play Books](#)

Table of Contents

Preface .. 5
Chapter # 1: Types of Comic Books .. 7
 1. One-Shot ... 7
 2. Anthologies ... 8
 3. Mini-Series ... 8
 4. Ongoing .. 8
 5. Graphic Novel .. 9
 6. Webcomic ... 9
Chapter # 2: Coming up with a Comic Book Idea 10
 Pay attention to your environment .. 11
 Get inspiration from movies .. 11
 Read novels .. 11
 Read other comic books .. 11
Chapter # 3: Tips for Developing Your Story 13
 Remember to develop key characters .. 13
 Give your characters good reasons for fighting 14
 Black moments are great ... 14
 Have a proper ending .. 15
 Don't be predictable .. 15
Chapter # 4: Coming up with Characters .. 16
 Revisions make great characters ... 16
 Keep the list of characters small ... 17
 Personality and background are crucial .. 17
 Draw sketches ... 17
 Make them unique .. 18
 Characters in your book must be different physically 18
 Colors Matter .. 18
Chapter # 5: Know Your Audience ... 19
 You will be able to use its language .. 20
 You will give your audience stories it likes 20

 Promotion becomes easier .. 20

 Writing the book becomes easier .. 20

 How to Identify Your Audience - ... 20

Chapter # 6: Making Your Comic Book ... 22

 Write Your Story ... 22

 Make Panels ... 23

Chapter # 7: Tips for Editing and Proofreading Your Book 25

 Revise one thing at a time ... 26

 Focus on grammar and spellings .. 26

 Don't just edit once ... 26

 Don't proofread it yourself .. 27

Chapter # 8: Promoting Your Comic Book ... 28

 Have a website .. 28

 Don't forget social media ... 29

 Ask people to share and recommend ... 29

 Join comic boards ... 29

 Sell at a comic con .. 30

Chapter # 9: How to Be a Great Comic Book Writer 31

 1. Read Lots .. 31

 2. Work with Others ... 32

 3. Learn from the Pros .. 32

 4. Don't Stop at One Book .. 32

 5. Get Feedback .. 32

Conclusion .. 34

Author Bio .. 35

Publisher ... 46

Preface

You definitely have a list of comic books you like. And I can imagine that they take you into a new world when you read them. Simply put, comic books are a great way to spend leisure time. I know people who enjoy these books more than movies and novels.

If you want to join in the fun and be one of those entertaining people with comics, then it's never too late to get in the game. If you can start writing comic books, you may get famous and make some money in the process. Furthermore, you will find fulfillment in that other people are enjoying your creations.

All that's required from you is to work hard and give your readers the best stories you can come up with.

However, there is one thing that acts as a roadblock for many – where to start.

How on earth are you going to come up with characters? How will your develop your story to make it entertaining? And how will you even hatch an idea that will turn into a great book?

If you are like many, you may be intimidated at the thought of all this.

In this book, I will show you how you can make a comic book. You will find everything you may need to know about this process. I have tips on idea generation, story development, character development, and more. All these tips will help you start and finish your book. Additionally, you will also find

info on promotion and becoming a great comic book writer.

I'm sure that you will enjoy the book. So without wasting anymore time, let's get started.

Chapter # 1: Types of Comic Books

Before you start bleeding your brilliant ideas on paper, it pays to know what kind of a comic book you want.

As a beginner, you will discover that some of these types are not your best options. They are suitable for those who have been in the industry for some time and have perfected their comic book writing skills.

Here are some of the types of comic books:

1. One-Shot
A one-shot comic book tells a story from start to finish. It is just one issue. Usually, these books have 20-22 pages, but they can be of any length. Since

you are just getting started, this is not the best book for you. You will have a hard time getting someone to publish it as no publisher wants to take risks with someone who is yet to make a name for himself. But once you are established, you can start making one shots.

2. Anthologies

These are a good option for anyone who is just getting started. With anthologies, you group with other comic writers and compile your stories into one book.

Selling anthologies is not as hard, as readers know that they get more for their money. This is the reason publishers are usually willing to publish a story even if it is from a beginner.

The only problem with these books is that you will have a limit on the length of your story, which may be shorter than what you want. But since you are just getting started, I'm sure it's not a huge problem.

3. Mini-Series

You definitely know what a series is. In this case, this is just a small series, usually between 4-6 issues. You can find other mini-series with 9 issues, but these are rare. Anything beyond 9 issues is considered a full series.

4. Ongoing

If you know you have got the energy to keep developing your story for years, then you have a good reason to make an ongoing comic book. Unfortunately, these are not the best for beginners. Readers will only buy from someone who is established. So again, you may want to keep this idea

in your locker until you are well known.

5. Graphic Novel
Many find it difficult to differentiate a comic book from a graphic novel, and it's understandable. The latter is simply a long comic book. It has a much more complicated plot than a comic book and is released as one issue.

6. Webcomic
You surely expected to see this somewhere, huh? With everything on the web these days, why wouldn't we have webcomics? So instead of making a book, you would just publish your story on the web.

In this book, however, we are focusing on comic books. So again, this is something you may want to pass on for the time being.

Chapter # 2: Coming up with a Comic Book Idea

Before you start writing your book, you first need to come up with an idea. Otherwise, the book will be all over the place.

Unfortunately, coming up with a great idea is easier said than done. You should be ready to spend your mornings, afternoons, or even evenings working on it.

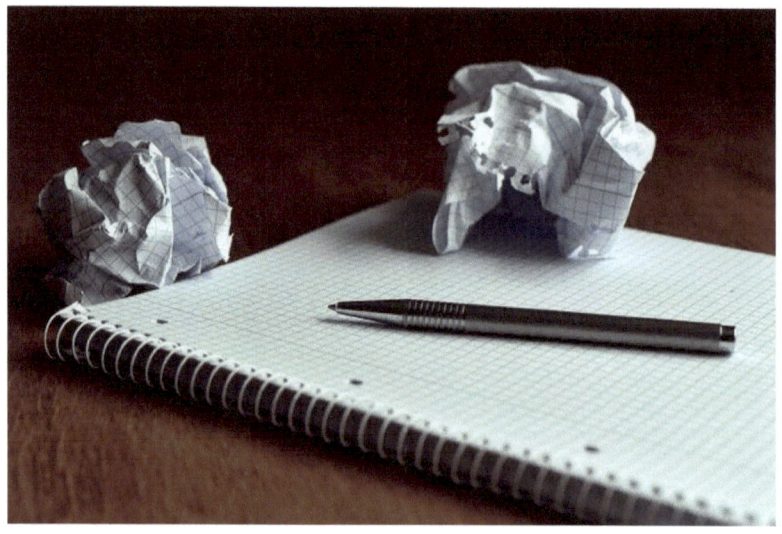

Through all this, you must keep yourself motivated. Writing a great book takes time and it's a lot of work. But first, you will need the right ingredient – and that's a good idea. So work on it until you find it. Sitting on your chair waiting for it to land on your shoulder is not the best approach.

To help you in the idea generation process, here are some tips to get your mind racing.

Pay attention to your environment – if you have read a lot of comic books, you may have realized that many of the stories are based on everyday events (of course, some writers come up with strange stories that you would think they are from Pluto).

So look around. What do you see? There are probably a lot of things going on. If you can push your mind just a little, you should be able to come up with an idea.

Get inspiration from movies – movies are full of great ideas. But this does not mean you can just copy them. You will get yourself in trouble. Instead, you should look at a movie and add a twist to its story.

So for example, instead of the protagonist being abducted by aliens, you can let apes take him.

If you can add other details to a story as simple as the one above, you may end up with something original and compelling.

Read novels – These are gold mines that you must tap into. Even better, there are a lot of these out there. You can even get them for free in some situations.

Just like with the movies, you will need to add your own ideas to have something original.

Read other comic books – by studying what others are doing in the industry, you will be able to deduce what makes a good idea for a comic

book. So get your hands on any comic book that you can find.

Any idea can make a comic book, but it is not every idea that can make a great comic book.

Once you have an idea, take some time to think of how you can present it in a way that's exciting. For example, a comic book about some superhero will get much attention. But another one explaining farming, may not get as many readers. However, it all lies in how you present the story.

If you are creative, you can make a book in the latter category more exciting than one in the former. So you must let your mind explore the depths of its creativity.

Chapter # 3: Tips for Developing Your Story

Now that you have an idea for your comic book, the next step is to expand that idea. This is the only way you can make the story more engaging.

You must take the reader through a roller coaster of emotions: there must be a time when he feels like crying; there must be a time when he smiles; there must be a time he is filled with fear, and rushes to the finish just to see how the story ends.

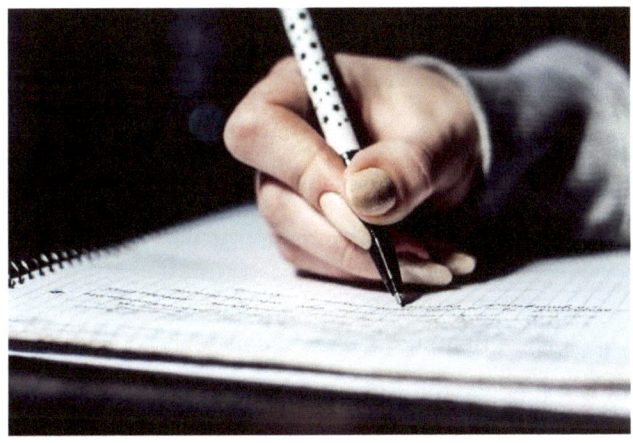

This is what will make your book interesting. It is what will make him remember it when he is at school, on the table eating, chatting with his friends, etc.

Below are some tips to incorporate in your story:

Remember to develop key characters – comic books with mindless action and no character development are a good way to waste your reader's time. You do not want that to be the description of your book.

While action is great, it should not be what determines where the story goes. Besides, without characters, there will be no one to do the action in the first place.

So you must spend time working on your characters. They must have personalities that reader can relate to.

Give your characters good reasons for fighting – Like I said, it's not many of us who appreciate reading comic books with nothing but mindless action. Your character does not need to get into a fight just because she spent 50 years in the Shaolin Temple – she must have a good reason for fighting (not always a physical fight).

Will she lose her life if she does not fight? Will she lose her family? And most importantly, why should the reader care that she fights?

Even if your character is fighting for a good course, if your readers do not like or relate to her, they will consider it as mindless action.

So character development is important. The readers must like your character before they can support her in her struggles.

Black moments are great – You certainly have watched a movie or read a book where the protagonist was cornered and it seemed that it was over for her. You sat on the edge of the seat fearing for her life. That is what a black moment is all about.

So make sure that you have such kind of moments in your book. But don't overdo it.

Using your imagination, find a way to make her win. For example, someone can come and save her. Or she may miraculously find a way out.

Have a proper ending – No matter how great your story is, it will need to come to an end. Your reader has other things than reading your comic book for his entire life. So have a proper ending that rewards him for reading your book. Usually, you can do this by making the protagonist overcome an impossible challenge.

Having an end in sight motivates people to read a book.

Don't be predictable – Once you have checked all the tips in this chapter, you must still ensure that your story is not predictable. Besides, if it is, what's the point of reading it?

Avoiding predictability is not easy. You will need to work hard to figure out how to twist the story. So think outside the box. See the situation from a different angle.

With time, you should be able to learn how to make clichés original. Watching great movies or reading some good books will help you see how others do it.

Chapter # 4: Coming up with Characters

Comic books are 50% pictures and 50% words. If you want your book to be successful, you must focus on both of these. Great words will not do much if you treat the characters as an afterthought. Likewise, great characters will fall flat if there are no words to support them.

Coming up with great characters is easy and difficult. It depends on how you approach it. But the one thing you must always remember is that winning characters are born with time.

Here are some tips to keep in mind:

Revisions make great characters – No matter how good you are, you must revise your characters a couple of times. If the pros do it, then you

too must do it. Although this is a lot of work, it's worth the effort in the end.

Keep the list of characters small – Since this is your first book, I would advise that you start with a small list of characters. Although it may seem fun to have everything you can think of in the story, you will have a hard time solving this huge puzzle. In the end, your readers will be confused, and perhaps, annoyed that they got your book.

For a start, all you need is a protagonist, antagonist, and a couple of other supporting characters. This will give you space to focus on other aspects to make the story fun.

Personality and background are crucial – no matter what kind of characters you have, they must have a personality and background. This is how readers will relate to them and understand what determines their actions.

Again on personality, do not make your protagonist be overly good. Likewise, do not make your antagonist be purely evil. They must have a balance and not exist in the extremes of their personalities. Characters that are perfect are boring. And so are characters that are too bad.

Draw sketches – By getting to this part, I assume you already have an idea of what you characters will look like. So go ahead and draw them on a piece of paper. You can make them as detailed as you want or you can just keep them as sketches.

Just ensure that you show how the major parts will look like (arms, legs,

head, hands, etc.)

Make them unique – the last thing you want are characters that resemble others already in existence. Your readers will not appreciate that. Originality is important. So add what you think will make your characters look different.

Characters in your book must be different physically – You may think this is a no brainier. But I see it a lot in comic books written by beginners. Although this is usually a child of bad drawing, you can also blame it on poor preparation.

So to avoid confusing your readers, make the characters different physically. Even if a reader makes a glance, he should be able to tell the character he just looked at.

The characters can be different in shape, color, size, etc.

Colors Matter – The color of your character can say much about its personality or the things it does. People associate dark colors with antagonists. And they also think of bright colors like yellow as belonging to protagonists. So make sure you get this right (but this is not a rule set in stone).

Chapter # 5: Know Your Audience

If you are writing this comic book for yourself, then you have no reason to know your audience. As long as you write something that's good to you, then you have done a good job. You are the only reader you should be concerned with.

Comic books, however, are made to be shared and enjoyed with other people. Unfortunately, the one thing writers forget is to understand who these other people are.

No matter who you are, you cannot write a book that's universal.

We are all different. What could be humor to you may annoy me. While you may enjoy reading love books, I may love those belonging in the action category. So as you can see, it's impossible to make a book that covers every taste.

And I can imagine that a book that tries to be everything can take you a whole trip to Heaven to finish reading it.

Below are some of the reasons it's important to understand who your audience is:

You will be able to use its language – if you can pinpoint who your reader is, you will be able to use the language he can understand. And as you already know, words make 50% of a comic book. So if they do not appeal to your audience, you have already lost half the battle.

You will give your audience stories it likes – people with similar interests will certainly be interested in the same kind of stories. So by knowing them, you will understand what kind of stories they would love to read. You job would be to create the story and give it to them.

Promotion becomes easier – if you know who your reader is, you will know where to find him to give him the book. Searching for him aimlessly will surely lead to a waste of resources.

Writing the book becomes easier – since you know who your reader is, what he loves, and everything there is to know about him, the process of creating the book becomes easier. You will not hit a block trying to decide if what you have in the book is what he wants to read.

How to Identify Your Audience - The process of identifying your readers is not easy. It takes time and a lot of research. Here are some questions you need to ask yourself.

- What are their ages
- What's their gender
- Where do they live
- What things do they do when free
- What kind of stories do they like to read, etc.

By doing this, you should be able to tell who exactly your readers are. And when you do, you can carry more research to discover what their lives are like. You do not exactly need to talk to them to find out what they love. But you can look at the things they like to say on social media, how others portray them in everyday life, etc.

Chapter # 6: Making Your Comic Book

By now, I'm sure you have a good picture of what your story will be about. I also assume that you have come up with the characters you will use and that you at least have sketches of what they will look like.

Having all this in place, you are now ready to start writing your book.

But before you do, I would advise you to sum up what you comic book is all about in one sentence. By doing this, you will force yourself to stay on track as you will be making the book. This is used in movie production all the time, you too can use it.

Write Your Story

There is no single way of writing a comic book. It depends on whether you will finish the book on your own, or you will take it to someone to help you with the drawings and everything else.

If you will be working with other people, it's important that you have a professional script detailing everything in your book. So when you give it to the other people, they will know exactly what to do.

The first thing you need to do is to create several time lines. These show what's happening in each scene. They describe the characters involved, the action taking place, as well as the words to be said.

Depending on how long your story is, this can take a couple of pages.

Make Panels

Once you have written your timelines, you will need to make panels for each. First, you will need to have a piece of paper. On it, divide boxes like you see in other comic books. They may need to be of different sizes and shapes (refer to any comic book to see how others do it).

When done, draw your whole story in these panels.

Depending on your preferences, you can write your words as you draw or do it when you are done. However, just remember to use a pencil. If you notice that you have made a mistake, you can easily erase it than if you use a permanent ink.

If this is just a sketch and you will be taking it to another person to give it a professional look, then you can leave everything in a sketchy format.

And when drawing your word bubbles, make sure that they do not take a lot of space and obscure the characters.

In addition to that, people will read the bubble on the left before going to the one on the right. So if you do the opposite, your readers will be confused.

Chapter # 7: Tips for Editing and Proofreading Your Book

All great writers know one secret - a book only gets better with editing. And this is the reason you are not supposed to use a permanent ink when you are drawing or writing your words.

As you will be making your book, you should know that mistakes will be invertible. You will do some things in a rush which will open the door to errors.

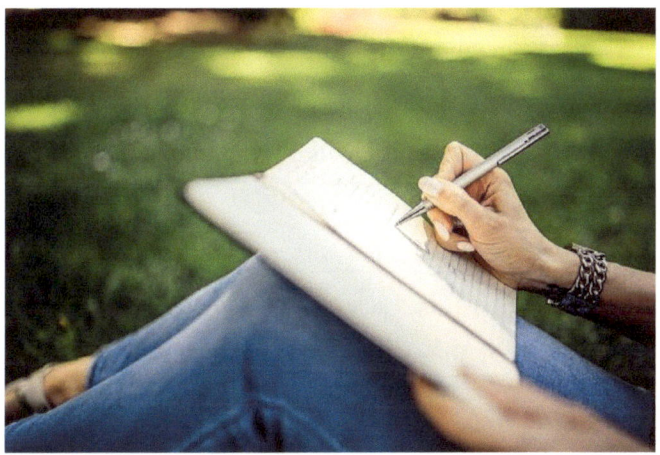

Although the reader can withstand a mistake or two, he will be put off if it becomes apparent that you did not revise your book. As a matter of fact, instead of enjoying the story, he will be enjoying the process of spotting errors.

So before you publish your book, you must make sure that you have revised it. Here are some tips to follow:

Revise one thing at a time – you may be tempted to edit everything at once. However, this is a very inefficient way to edit a book. Rather, you must do a single thing at a time. So if you want to check the flow of the story, just focus on that.

If you want to look at your drawings, do nothing else.

The best part is that most comic books are short. So this process is not very overwhelming.

Focus on grammar and spellings – your readers will forgive you if you make a mistake in your drawings because they know that drawing is not easy. Some will even think a mistake in the drawings was done on purpose. And in certain cases, some will not even notice the mistake.

However, if you grammar or spelling is incorrect, you can bet that the majority of your readers will be frustrated with them. And this can discredit your book as well as your ability to make great comic books.

To avoid this, get your grammar and spellings right. If you know this is something you are not good at, get someone to help you.

Don't just edit once – the thing with editing is that you do not get it right the first time. So to ensure that your book is as perfect as it can be, you will need to edit it a couple of times. If you do it just once, you will still leave some mistakes. You have to edit 2 or more times. The more you do it, the better.

Don't proofread it yourself – Although you have edited the book several times, there will still be some mistakes that will escape your eyes. This is the reason you need to bring in other people to help you with proofreading.

If you can't find anyone, then you must put the book away for some days. The longer it takes without looking at it, the better. When you will get back it, it will no longer be in your memory. So you will see it differently. If there were other mistakes you missed, you will surely catch them this time.

Additionally, it also helps to proofread the book in a new environment. It's all about throwing your mind off its game.

Chapter # 8: Promoting Your Comic Book

By reaching this far, you have learned a lot. If you found the experience challenging, I can promise that your second book will be easier. But nonetheless, it must be fulfilling to finally make your own comic book.

Unfortunately, there is one important thing you need to do and it's not very sexy. That thing is promotion.

If you do not tell your readers that you have a comic book, then don't think that they will miraculously find it. You will need to go out there with the book on a nice plate and say, "Hey, I have got this book for you. I think you will like it."

Now this is not as easy as going out and screaming in the streets that you have a book. Or giving it to everyone you meet. You need to play smart.

Here are some things you can do to promote your book:

Have a website – the first thing you will need, considering that we live

in the digital age, is to get a website. With this, you will be able to showcase all your work. Additionally, you will get your name known in the industry and open opportunities for more jobs.

If you have content on your website that people want, you should be able to increase your traffic. And once you start getting a lot of hits, you can be guaranteed that success is nigh.

Don't forget social media – ignoring social media is a stupid move. It can only be an excuse if you know your audience does not use social networks. So get yourself an account on Facebook, Twitter, or whatever social site your audience hangs out on.

You should not be tempted to buy fake fans or followers. These provide no engagement which only promotes to the death of your social presence. Instead of taking shortcuts, build your followers or fans the traditional way; have great content on your social accounts.

Ask people to share and recommend – We all need help from others most of the time. So whenever someone picks up your book, explicitly ask him to recommend or share it to his friends. Although this may look like a desperate move to you, your readers may not view it as such.

Join comic boards – there are a lot of comic boards on the internet. So search for these and become a member in those you like. In order to stand out, comment frequently and make sure that you are only providing useful information.

Now and then, you should mention your books. Others will start to take notice of you and will want to discover some of your work.

Sell at a comic con – I would only recommend that you do this when you have a number of books under your name and have some readers who love your work. Being successful at a comic con requires you to be smart. If you are not, you may end up losing money in the process. So do your research first.

Chapter # 9: How to Be a Great Comic Book Writer

When you are done with your first book, you may be motivated to write another one. But this time, now that you know how to write a comic book, you may be wondering how you can become a great comic book writer.

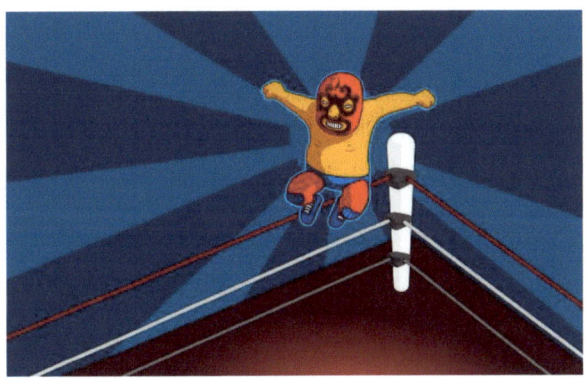

Greatness has its perks. You will be able to make money from your art. And most importantly, you will get your name known and open a lot of opportunities.

But the path to success is not easy. You will need to work very hard to get there. Below are some tips to help you achieve that.

1. Read Lots
If you want to be good at something, you need to study what other writers are doing in the same industry. For you, this means reading other comic books. The good thing is that there are a lot of these and you can even get some for free.

As you read each book, try to analyze its strengths as well as its weaknesses. See how other writers draw their characters, divide their panels, write their text, and more. If you can do this with a number of books, you should be able to discover some patterns for making great comics.

2. Work with Others

No one can be good at everything, even the pros. There are always some areas that you can use some help or improvement. With that, you may need to band with other writes so you can share skills on comic book writing. A group of amateurs is even better than working on your own. In addition, you may discover that you are more motivated when you work with others.

3. Learn from the Pros

If you know someone who is really good at making comic books, ask him to teach you some of the things he knows. However, he may not be willing to do it for free. So if you have the money, you can hire him.

But I would only advise that you go this route if comic book writing is more than just a hobby.

4. Don't Stop at One Book

The best way to master writing comic books is to keep writing them. So as soon as you finish your first, get onto the next one. By doing this, you will be automatically learning how to be a good comic book writer. And if you couple this with learning, you will accelerate at an even wondrous rate.

5. Get Feedback

There are things that you may overlook as you write your comic books. You

may think of these as being trivial. But it's only when you change them that you see your books transform for the better.

So for each book you write, ask for people's honest feedback.

However, asking for feedback is one thing as taking it can be a hard pill to swallow. But you must understand that this is what will make you great. So take all criticism with a smile of your face. Always view it as a chance to grow.

Conclusion

I would like to thank you for reading the book. I am sure you now have a detailed picture of what it takes to write a comic book.

Hard work is everything in this industry. Even though your first book may not be your best, you can bet that it will open the door to better books. You just need to keep writing more. With time, you will discover the secrets.

If people give you feedback, always take it. It's the only way you will grow as an artist. Furthermore, you must take time to study books by other writers. And before you publish each book, you must ensure that it is free from errors.

For any book you will write, you must develop your characters. Without them, your book will be like a house without a foundation. Great characters are what people remember when they are done reading your story. Any action in your book will need characters before it can take place. And your readers will feel the connection to the book if they like the characters.

But great characters are nothing if your story sucks. So you should also take time to get this part right. Your story must be entertaining and original.

Author Bio

Dr. Usman is an MD, now pursuing his post-graduation degree. As a medical doctor, he has deep insight in all aspects of health, fitness and nutrition.

He is a certified nutritionist and a personal trainer. With these qualifications, he has helped countless people reach their health, fitness and weight loss goals.

Dr. Usman is an avid researcher with 20+ publications in internationally accepted peer reviewed journals.

He is an accomplished writer with more than 5 years of writing experience. In this time, he has produced countless blogs, articles and research work on topics related to health, fitness and nutrition.

He is a published author with more than 100+ books published and several more in the pipe line.

Finally, he runs his own blog and posts health, fitness and nutrition related articles there regularly. You can visit his blog at http://hcures.com/

Check out some of the other JD-Biz Publishing books

[Gardening Series on Amazon](#)

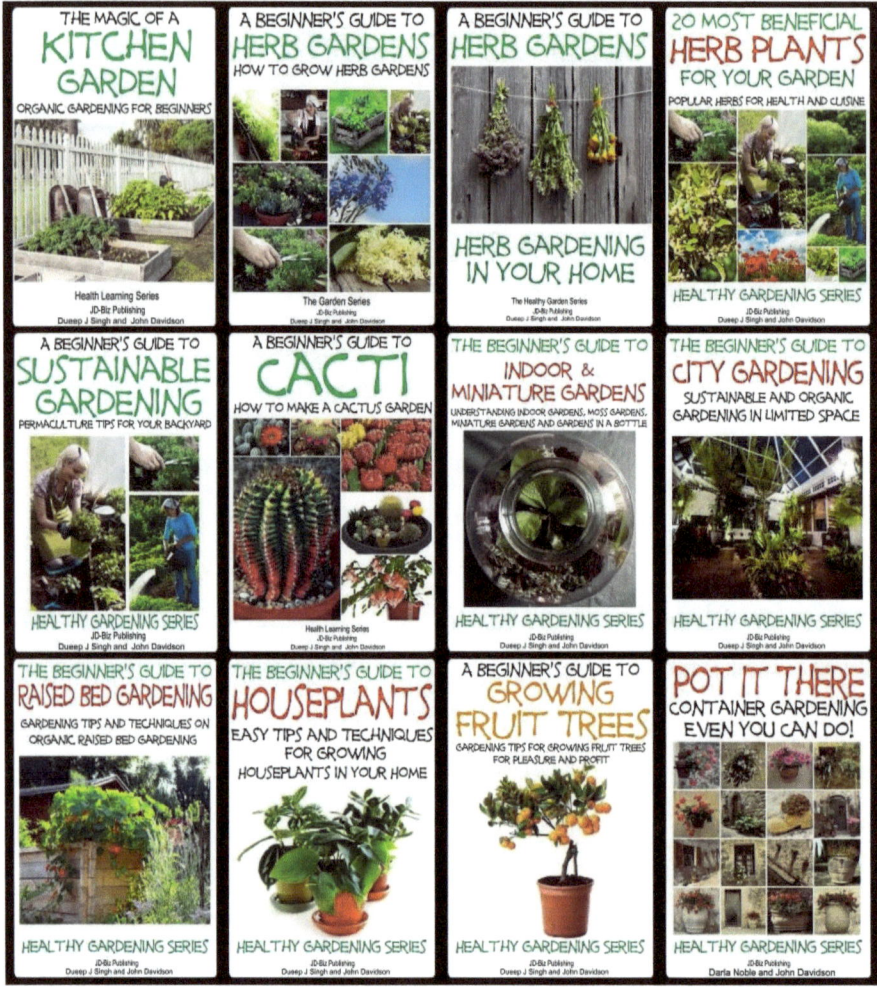

Download Free Books!
http://MendonCottageBooks.com

Health Learning Series

Country Life Books

Health Learning Series

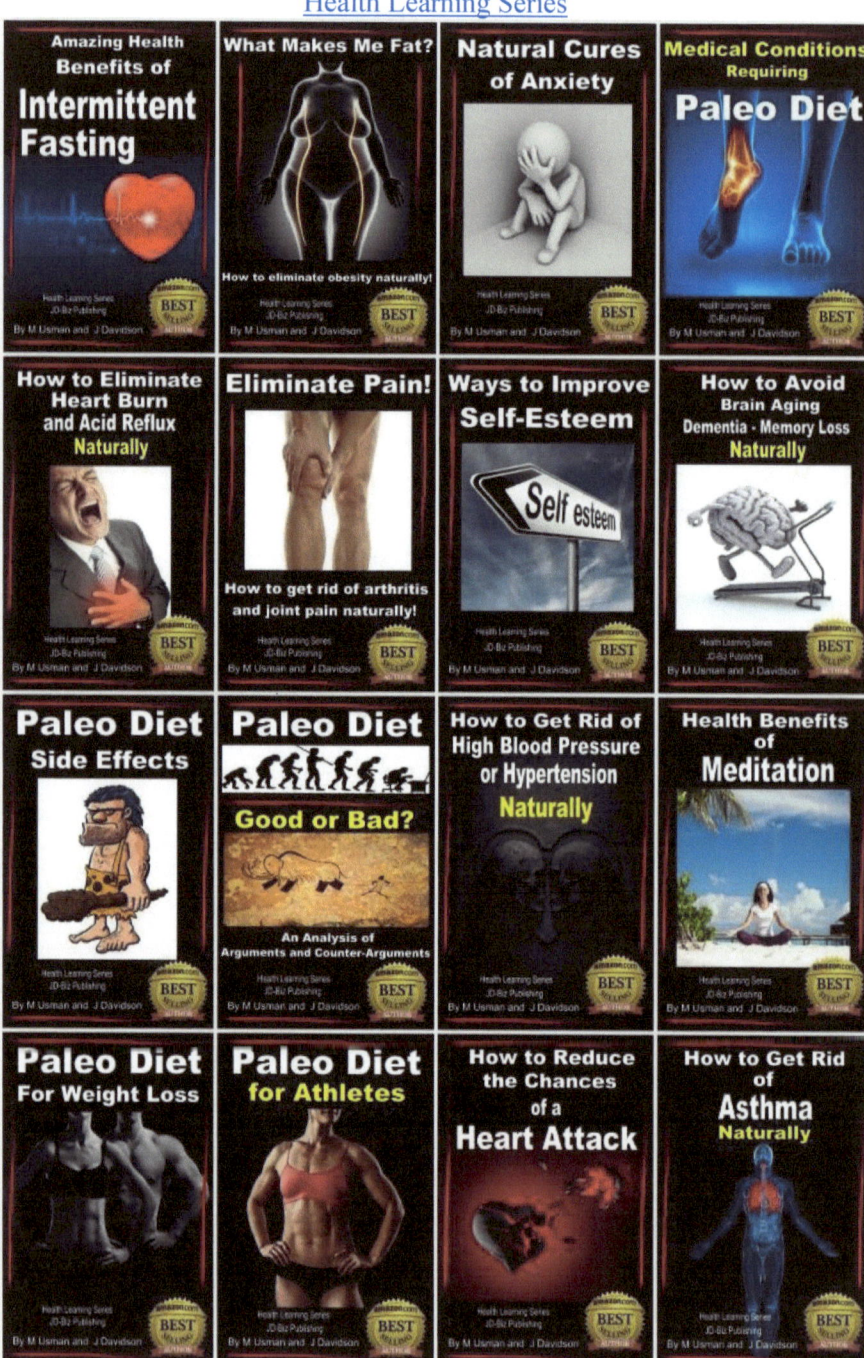

Amazing Animal Book Series

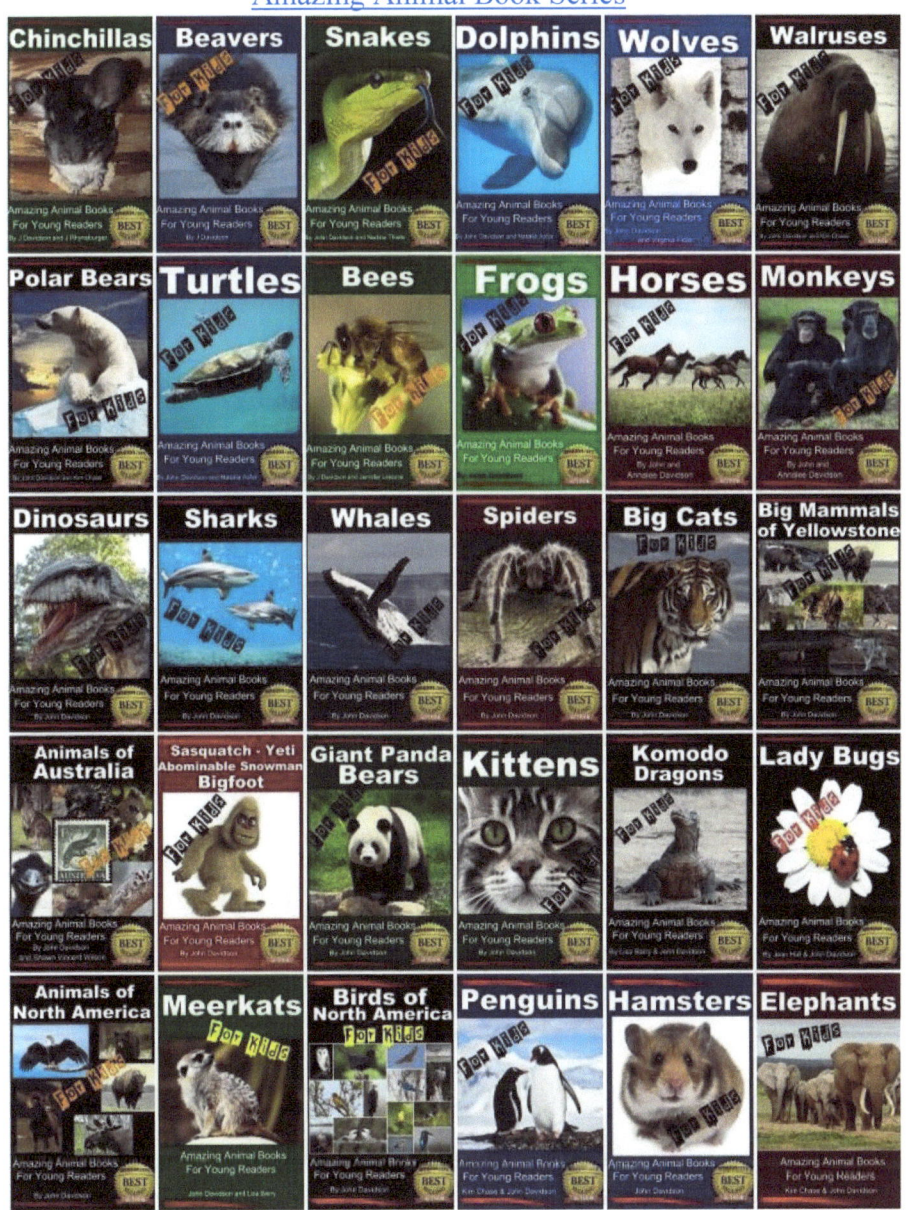

Learn To Draw Series

How to Build and Plan Books

Entrepreneur Book Series

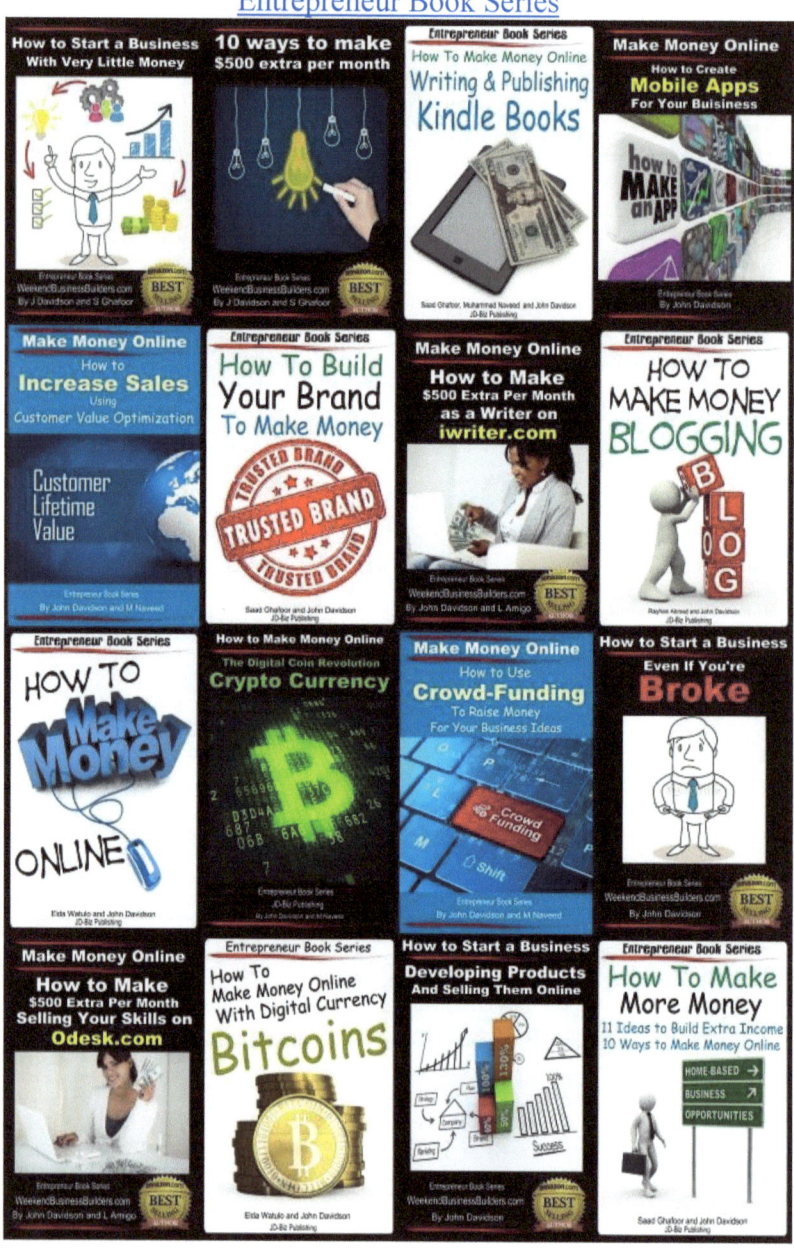

Our books are available at

1. Amazon.com

2. Barnes and Noble

3. Itunes

4. Kobo

5. Smashwords

6. Google Play Books

Download Free Books!
http://MendonCottageBooks.com

Publisher

JD-Biz Corp

P O Box 374

Mendon, Utah 84325

http://www.jd-biz.com/

www.ingramcontent.com/pod-product-compliance
Lightning Source LLC
Chambersburg PA
CBHW040925180526
45159CB00002BA/608